We Want Our
Bodies Back

Also by jessica Care moore

We Want Our Bodies Back

Poems

jessica Care moore

AMISTAD
An Imprint of HarperCollinsPublishers

HarperCollins books may be purchased for educational, business, or sales promotional use. For information, please email the Special Markets Department at SPsales@harpercollins.com.

FIRST EDITION

Designed by SBI Book Arts, LLC

Library of Congress Cataloging-in-Publication Data

Names: Moore, Jessica Care, author.
Title: We want our bodies back : poems / Jessica Care Moore.
Description: First Edition. | New York, NY : Amistad, an imprint of HarperCollinsPublishers, 2020. | Summary: "A powerful full-length collection from jessica Care moore, one of the leading spoken word poets of our time"—Provided by publisher.
Identifiers: LCCN 2019045262 | ISBN 9780062955289 (paperback) | ISBN 9780062955272 (ebook)
Classification: LCC PS3563.O6185 W4 2020 | DDC 811/.54—dc23
LC record available at https://lccn.loc.gov/2019045262

20 21 22 23 24 LSC 10 9 8 7 6 5 4 3 2

for Sandra Bland

for all our beautiful fierce feminine bodies

also,

In memory and in celebration of
Ntozake Shange

I told you: I wld not exist
if not for you.

you replied:
What's a girl to say, I'm honored.
. . . Thank you, Tz

Now . . .

 what?

Your silence will not protect you.

—AUDRE LORDE

CONTENTS

PART THREE

I Got Life

INTRODUCTION

My eyes have been waiting on my body since I was about 9.
I had a strong case of continuous de/ja/vu during my elemen-
tary school years. I was so curious as to when I was gonna
actually experience my past life again. I knew it was waiting
on me. I found the sun and small animals magic.

I was allowed to be a girl.

My body did not
grow up too soon. I was late.
I was one of the lucky ones.
There was a disgusting long haired man who
tried to destroy me early.
He did our family's lawn care. One day in our garage
he played *itsy bitsy spider* up

one of my pretty dresses.

I wasn't older than 5 or 6. Smart enough to know he
 was wrong and told my
God Mother Vivian James what happened. I saw him
 one time after that.

I was hoping my daddy had killed him
Shot him dead with one of his long brown
deer hunting rifles

I wore my hair in two bushy ponytails, canvas no-name gym shoes, shorts with bright colors and white trim. I was naturally athletic and petite. Tough with "I have tall, big brothers and protective daddy" confidence.

I grew up with scars. 14 stitches took over each cheek
 by 3 years old. 7 on each side.
One inch from being blind. "She's one inch from
 being blind," the doctors always said.

That became my favorite number at 7 years old. 7. How we hold on to these small things our entire lives is still amazing to me. 7 became my protection. The number on my softball jersey in 7th grade. I didn't make the basketball team at my majority white Polish Catholic elementary school. This devastated me. I decided to be a cheerleader, just so I could be in the gym. I hate the word hate, but I hated cheerleaders more. I just wanted to see all the basketball games. The

white girls played so different than the boys on my block. My crossover was quick and soulful, and I didn't pass the rock in my backyard with the robotic technique these girls used with foreign perfection.

My body just moved different.

My body was never an issue for me until I realized other people were looking at it. I was always pretty average sized, and until high school my chest was pretty flat. Being an athlete developed a confidence in my body that had nothing to do with what it was shaped like. I was always interested in how fast it could move to catch a ball speeding toward me at shortstop, or how my knees would happily hit the floor to dig up a volleyball to be spiked by one of my taller, stronger teammates. "Cinderella" is what the upperclassmen on the team called me. I was nobody's animated princess. I was definitely hiding my tiara behind ponytails and unapologetically thick, nerdy Julius Irving-style glasses I wore proudly while hitting j's on my high school basketball court.

Whoosh.

I was a virgin my entire four years of high school. The language of losing your virginity is always centered around

girls and women giving up something. When you decide to give your body to someone, what exactly do you receive in exchange?

If we, in fact, do "choose" to "give up our bodies," when do we get to have our bodies back?

The door to womanhood
can be only entered by a man?

Where is the exit?

In my third book, *God is Not An American,* I use the metaphor of our monthly moon cycle as a rite of passage. Blood blossoms our beginning. As I write this, daily headlines with Hollwood stars and politicians being accused of sexual harassment and improper groping dominate. Tarana Burke, the black woman who started the #metoo movement, is finally being recognized for her work to bring this issue to light. We all have a #metoo survival story. If not a rape of body, it is a rape of spirit. If not a demeaning comment, it may just be a quick feel.

This is what happens to us all in public settings. No one

is safe from being treated this way. It doesn't matter what poems you write, or awards you win, the reality is your body can be in danger in public spaces, let alone private ones.

I'm considered one of the lucky ones.

I've experienced attempts at erasure from the male dominated entertainment industry, and definitely uncomfortable moments of flirting and aggression during decades as a working artist. In 2004 I decided to fight the erasure of women's voices and bodies by spearheading a movement, Black WOMEN Rock! with Funk icon Betty Davis at center. For 15 years we have gathered to reclaim our place in American music history. We sing and play rock and roll music with a full orchestra of black women musicians, we celebrate our sexual and political power. We create a safe space to speak about the sexism and silencing of black women's voices in the arts. Unlike pioneer Betty Davis, who abandoned a music industry she forever changed—a place that could not handle her before her timelessness—we have each other.

When I wrote the poem "We Want Our Bodies Back," Mike Brown had already been murdered in Ferguson. His body purposely left for hours to bleed out in front of all his friends, members of his family, peers, and younger children in the neighborhood.

American terrorism against black bodies happens in broad daylight.

I read the poem for the first time at a fundraiser with hip hop artists and activists from around the country. I wanted to insert Sandra Bland's body into the progressive but still very male dominated series of protest concerts.

When my body was against the ground in Ferguson, with Talib Kweli and Rosa Clemente, I remember looking up at the AR15s pointed at us. I recall seeing members of the Bronx--based activists, The Peace Poets, on the ground, and another one disappearing behind us. He'd been quickly swooped up by the antagonistic police chasing down the locals like prey. I remember one black cop's face looking down at us and finally saying, "Let them go."

My body hurt for a very long time after that moment.
Several days later, I finally cried.
I can still taste the air in Ferguson.
I can still smell the cement and gas
devouring my organs.

Always break their hearts, first.
Past life body finds a survival guide
to the future

I was allowed

to be

a girl.

PART ONE

Wild Is the Wind

January 3, 1994

I wanted to see my daddy's body
I wanted to see what they had done to him.

not the angels,
not God.

They didn't take him. I was convinced.

He was thin and tall and southern sophisticated
kool milds and southern comfort next to his bed
smile that could capture the attention of women
half his age.

I laid down in his twin bed the morning he *died.*
I wanted to find the grooves of his body inside
the fabric so i could bury myself inside of what
he left behind.

A part of my body
would always be dead *after this day*

I examined the house that was never *my house*

I searched for clues. I rolled my eyes at the strange
man who was walking around. I didn't trust him, or
his smell or his eyes. I didn't trust the woman
who was my daddy's young girlfriend at the time
of his death.

I didn't trust many women
after my daddy's body left Detroit.

I wanted to see him.
Why can't we see him?
Henry Ford Hospital had his body *somewhere.*
I forever hate hospitals.

The doctor told my brother Jonny it would be
better to
just wait until he *was prepared for the*
 funeral.

We left my daddy's body with these strangers
My brother didn't notice, but i was screaming
 no one noticed, but i
 was flying

I was kicking the doctor in the gut and running

Down the white doorways to find my daddy's body

So i could bring him back

home with me.

Mother Earth Prayer

You may want to reconsider only praying
to your father for mankind

God.

Considering the vulnerable state of humanity,
you may want
to call

your momma.

She Was.

I have convinced myself
I speak french
Somehow I will find a way to make
a Perfect sound

An: un/english

I don't know
What else to do
With this language cept
Murder it.
Dig out its eyes. Every vowel. Till it suffocates
Choke the breath out of this alphabet
I need more than 26 letters to articulate
How I survived you.
How we survived
calculated attempts to blow
the heads off our sons

Slavery in a digital world
I have buried all the men i loved and will
Ever love

Before you could
get to them

Now what, mutha fucka

I won't allow you the privilege of their death
You will not capture my personal ghosts
make them your public prize

I will swallow them down
Said a whiskey straight
But you don't drink poet

The roundtable turned square
I'm not drunk enough to make a clear sentence.

I prefer a sober hallucination

the pill of this country
is difficult enough to chase
water. no ice

is watching me dance
with myself and everyone else
in this cynical room

you know i'm making love to you
i don't have to tell you your ear
its attached to the side of your head

these few seconds pulled against
your chest is honeymoon in jamaica

the editors are resisting my twist in plot

we pose for a photo that is really not
about the photo

is this a poem or a romance?

the poems know i got a trail of hearts
following behind
the train tied around my waist
dragging loud empty canned ideas left over
from one of those marriages

so long ago i can't remember
what i wore underneath

poems never really want to commit

why are you putting on that *red* dress

?

to camouflage the bloodshed of the
off-white failure
Babatunde played drums
Imani Uzuri sang

Veil full of ivory cowries
cldn't turn *The Cloisters* into
The Door of No Return
We always return in new forms
horses
red dresses
convertible mustang

quite gangster
my daddy must have yelled from
his madison, alabama, grave

"I will kill him"
because our daddy would have
whispered my brother Ed pacing in front of
our three thousand square foot lie.

jessica is always in love

love is a distraction from love
life is a conceptual art installation

I found my body in ceramic pieces
 thrifting
in new smyrna, florida
with Radcliffe Bailey

plastered afroed yemanja
left hand removed
decapitated flower
thick white curls still in place
despite the nets

used to be somebody's light

she spoke french
senegalese dialect

our bodies
fell in love
before they could hide the evidence
reglued our stories

queen kuntas

she wears the same mauve
petals my grandmother wore
in the one photo i possess of her.

you get used to not ever
knowing your grandparents

figure the ocean is our most authentic
photo album

tide don't lie

here comes another body
Crashing against the family

 Tree

we just know we Moors

 conquered Spain

There's that one photo my daddy kept
Of my great grandfather
in a full feather headdress

My indigenous DNA test wasted
traces of Southern Comfort
Shotguns, deer meat
Afro still in place

Piss test found Nat Turner promises
And one page of his bible

Piss test swam to huntsville
Well full of moonshine & moonlight

How can one bladder
Hold all that water

?

You gotta ocean between your legs girl

Oya laughed
Aretha died a little more
every time we played the record

Naima inspired Naima.

What else do you want from us?!!!!

You never forget the ones you killed early
They haunt you

"You will not have my sons"

Écoutez

You will not have my sons
I don't know what else to do with
this language
 cept kill it!

Marriage isn't for everyone
Said the woman who wants to fuck my
Husband

She was right
But death is
A commitment we all make.

Who will pick out my dress
Who will interrupt.
Refuse this wedding to continue
?

The flower girl has my grandmother's eyes
Amiri Baraka got my daddy's moonshine
in his left pocket

Her body, ashes along an amethyst skyline
Convertible white *cadi* racing cross the clouds

Body pushing hard against the wind
Decapitated afro. Pitchfork combs through nappy
deferred dreams

She was
perfectly positioned for takeoff
Check the skies for the purple smoke
Poems still recovering from the self inflicted

Fire.

I promise.
She was
somebody's light.

We Want Our Bodies Back

If black women could
be cut down. No.
Removed, gently,
 from American terrorism.
Who would break our fall?
Which direction would we travel
to feel safe?

wild is the wind.

If we could turn in this skin, these
sharpened bones. this brain full of
power & history. who would we
Resemble?

invisible doesn't come
in black.

how many nervous breakdowns
how many funeral black dresses
how many fibroids
how many nooses

how many of our bodies must be raped?
cut into pieces. burned inside garbage
bags. Buried

?

how many of us
blossom a beautiful tree of life
& pray their pride isn't
cut down the middle/reduced to trunks
or a close friend doesn't die climbing their limbs
attempting to simply grow outside the gritty soil
they were planted.

i put a spell on you.

Holly Hobbie ovens
girl scout cookies & barbie dolls
don't prepare our revolutionary daughters
born with
capes & wings
to have a pig's knee pushed into their backs
girls raised by wolves
taught to disappear to be quiet
to not talk about it
how much black breath is allowed space

in the state of TEXAS?

a place that has sucked the life out of countless
miscounted. uncounted brown. poor. women.
die here.

I got life.

Sandra Bland got the death penalty
for a traffic stop. Her body was 28
years young.

How to make sense of our bodies?
bodies burnt by cigarettes
bodies smoked out their own neighborhoods
bodies with abandoned lungs and hearts
bodies mistaken for women
when they are still girls

How do we construct a survival guide, a poem
for our daughters' bodies
without throwing up our breakfast?
How do our mothers' bodies not implode after
telling our sons to comply, to not speak, to keep their
heads down, to allow their bodies to be dragged
by racist police

?
Jim Crow ain't never flown with this much wingspan
Eagles running for safety now.
For the reach is deep & southern & midwest
shadows the east
lands in the west

Texas—you will always be Mexico
in denial.

Poet Ron Allen asked for his body back in 1996
and we are still waiting.

We want our bodies back
We want our bodies back
We want our bodies back
We want them returned to mothers
without blood without brains exposed
without humiliation without bruises
without glass without fire

we want our bodies back

we want our cities back
we want our culture back

we want our land back

we want our streets back

we want our freedom

we want our justice

we want our bodies back we want our bodies back

we want our bodies back we want our bodies back

we want them wrapped in white silk

we want them paraded around the

white house. we want these flags

you stand up for at baseball games

at half mast

we want national holidays in honor

of our bodies, our knees, our prayers,

our ears, our genitals, our eyes, our

fingers, our feet.

we want 21-gun salutes when we

enter a room

we want our bodies back

we want them anointed in oils

we want them worn around your neck

we want them remembered we want them worshipped on
 sunday.

we want our magic you try to bottle

we want our essence you attempt to steal
we want our elegance our sex our walk
we want our cool we want our recipes
our intelligence our science our stars our history

I want my Moroccan nose
I want my holy water breasts
I want my Maasai legs/I want my alien arms
I want my ivory coast mouth/I want our breath back
I want our time back/I want your foot off our girls' backs

I want all your badges back

I want you to evaporate into dust like swatted moths

don't cut me down from the noose
let my legs dangle for the devil
what a spectacular magic show

Why you turn the cameras off?
this is a simple ballet. you got front row.
this is your venue.
this cell. this hole. is no one's home.
is no place for a woman to die.

you probably never heard of Judith Jamison
Katherine Dunham.
Oh, we know how to get
our legs in the air. we know how to elevate
use our bodies to tell a story
of middle passage.
of survival
of lynchings

you have always loved our bodies
under your control.
don't you touch me.
don't you take me down
don't you touch my body.
don't touch my music. don't touch my patience
don't touch my car door. don't come near my window
don't talk to me in that tone

this body of work got work to do

I'm resurrecting my body
in new forms daily
watch for me
in your deepest sleep

black is the color of my true loves' hair

listen for my songs
watch for my walk
listen for my voice
my black girl attitude
watch my body resist
your death traps
watch me rise
watch my rebirth
watch us rise up
from this new jim crow
from these new unspoken
apartheid laws

we want our bodies back
we want our bodies back

we will take them.
protect them.
remember them.
remind you.

remember you.
Sandra Bland

We will never forget your brown body
your mind your pride your spirit your love
your vow to do God's work
we want your drive from
Illinois to Waller County back.
We want all our daughters back
& we want them
back

Now.

I am not ready to die

A little more today

My nails are polished a bright aquamarine
My skin smells like the ocean
In my hair I am wearing the flowers he left on my doorstep

Tiger's eye and turquoise are wrapped round my wrists
Do I look like I am attempting an early death?

My headphones sound like Sade
I wish these new girls would get the fuck
off their knees and transform

a room

With subtle power and grace

 Sade doesn't really dance, poet
 And—that is the point.
When did it become okay to die in this country
On our knees?
The walking dead—a 24 hour day spa

They parade in groups
Hell, i need a massage too
But, at what price?

I gotta stand behind mediocre bars
just Because the kids rock to it.

?

I've yet to hear an emcee destroy this
Alphabet more gangsta than Ntozake

So, I ain't ready to die today.

Won't participate
in the spirit massacre of
Our children.

My throat is on fire
My pen is hot

Ntozake is dead.
Ntozake will never die.

I'm more alive at 47 than most of these
Wanna/be Euro inside-out millennials

I've graduated from digital slavery

Master Class.

I read books without screens
I have sex with men my age
whenever i feel like it.

I love my hair, my ass, my breasts.
I'm clear my power is between my ears

inside my chest.

Black girl magic doesn't grow between our legs

This is the mythology of men.

How much
? to get you off your knees?

Sis?

This pen is a knife
Stabbing out the hearts of dead trees
These trees already dead, anyway.
A walking dead urban forest

We

Are Surrounded

So, why continue
to climb?
to write?

Because I ain't ready to die today
Or tomorrow.

Imma keep living inside poems
You didn't know were left

for you.

If you would just get off the got-damn
FLOOR you could see

All these poems
All this royalty
All this world
They attempt to kill you with

Is really your universe to inherit
To change, to rebuild

Get off your knees

Stop CRAWLING for them

Stand up. Queen.

Latifah
Lyte
Lauryn
Missy Elliott
Left Eye
Bahamadia
Rah Digga
Roxanne
Rapsody
K' Valentine
Mama Sol

Microphones are not stripper poles

Sonia
Audre
Maya

Ntozake

Jayne

Lucille

Nikky

Nikki

Toni

asha

Staceyann

Ekere

Mahogany

Elisabet

Liza

Meshell

Me.
Us.
We need you

To stop dying
Stop dying
Stop dyyyyyyyyyyiiiiiing

To be less
than who you were

Destined
to be.

We need you to outlive death.
In all its forms.

Live
Live
Live

So patriarchy
can finally

 die.

PART TWO

I Put a Spell on You

I used to be a roller coaster girl

(for Ntozake Shange)

I used to be a roller coaster girl
7 times in a row
No vertigo in these skinny legs
My lipstick bubblegum pink
 As my panther 10 speed.

never kissed

Nappy pigtails, no brand gym shoes
White lined yellow short-shorts

Scratched up legs pedaling past borders of
hummus and baba ghanoush
Masjids and liquor stores
City chicken, pepperoni bread
and superman ice cream
 Cones.

Yellow black blending with bits of Arabic
Islam and Catholicism.

My daddy was Jesus
My mother was quiet
Jayne Kennedy was worshipped
by my brother Mark

I don't remember having my own bed before 12.
Me and my sister Lisa shared.

Sometimes all three Moore girls slept in the Queen.

You grow up so close
never close enough.

I used to be a roller coaster girl
Wild child full of flowers and ideas
Useless crushes on Polish boys
in a school full of white girls.

Future black swan singing
Zeppelin, U2 and Rick Springfield

Hoping to be Jessie's Girl
I could outrun my brothers and
Everybody else to that
recurring line
I used to be a roller coaster girl

Till you told me i was moving too fast
Said my rush made your head spin
My laughter hurt your ears

A scream of happiness
A scream of freedom
Pouring out my armpits
Sweating up my neck

You were always the scared one
I kept my eyes open for the entire trip
Right before the drop i would brace myself
And let that force push my head back into

That hard iron seat

My arms nearly fell off a few times
Still, I kept running back to the line
When i was done
Same way I kept running back to you

I used to be a roller coaster girl
I wasn't scared of mountains or falling
Hell, I looked forward to flying and dropping
Off this earth and coming back to life

every once in a while

I found some peace in being out of control
allowing my blood to race
through my veins for 180 seconds

I earned my sometime nicotine pull
I buy my own damn drinks & the ocean
Still calls my name when it feels my toes
Near its shore.

I still love roller coasters
& you grew up to be
Afraid of all girls who cld

 ride

Fearlessly
like me.

Because if i don't write

Because if i don't write
my body will finally cave
or i will evaporate.

Because if i don't write
black girls won't know i left
them a trail of tears
to find themselves
So they can get lost again
& one day

 find me.

Because if i don't write
Someone will say Sylvia Plath and
Emily Dickinson did not shit on a toilet or
ever go outside.

Ntozake Shange will never discover rainbows
Maya Angelou won't ever speak
And I will have to convince myself
That a man who is 5'6" can actually date me.

Keep Writing!!!!!

Because if i don't write
My fingers may fall off
or my tea
Kettle may melt &
lose its defiant whistle or the
Detroit Pistons
Would have never moved
 back downtown

Because if i don't write
You will write for me
tell historians black girls were
 crazy
 invisible
 lost in time
Wishing to turn our bodies inside out
Become unrecognizable to our own mothers
Desecrate our faces
because we hated our own

mirrors

Because if i don't write
There will never be a super heroine named
Salt who will save the future by her
ability to see herself
in
it.

Because if i don't write
I will live in fear
die with hope

Never laugh fight or dream
just cope.

Because if i don't write
You will write me off
Or academically erase me

I know.

Prophets Have Died
for PhD's

I write to live
to prove to black girls everywhere

we are possible

& the world we created with one Kemetic push

belongs to us
too.

I made myself like Maya

(for my son King)

i've been digging my friends
out of Detroit since 1984.
i remember the glove my daddy wore
this is abandonment porn

for you.

this is my michigan hand
my pink/my tan/my line breaks/my welfare line/my break
 ups/my wedding finger/
my fuck ups
my hand shaker/my poem writer/

my text to you.

my inbox/my tear holder/my proof of life.
my hair twist/my braille reader/

my touch/my fears/my jumpshot/my fastball catcher/my one
 night stand/
my three month lie/

my imagination.

my protection/my candle lighter/my fire starter/
my hand in yours/your random whores/my chores/my
 legend/my mythology/
my legacy
no one gave it to me
so i made myself like maya
no one taught me i was necessary
so i made myself like malcolm
no one loved me the way i loved
so i loved myself fierce as ntozake

i am not the intro.

i am the breath of beats/Ecuador heat/
turquoise toes & jazz feet/

whole wheat.

never white/no rice/no potato/
this week i am all green.

i am not the new black/
i am red/like my grandfathers' feathers/
i don't know all the rules/to my family headdress/
some of us/had to relearn how to dress/

in this Western.

ink still wet from the last lover
He forgot to send me flowers
i give them 72 hours
to die off.
the stems usually last longer

i don't want your
silly ring.

no one gave it to me

so i made myself like maya
no one taught me i was necessary
so i made myself like malcolm
no one loved me the way i loved
so i loved myself fierce as ntozake

a consistent music. film plot
finally makes it beyond my waistline.
poems are my first attempt at freedom
longing for alien blood in any human vein

i still love *Lucy*.

the first kiss from African lips/the pull of/
her original hips/

She is famous without the fame.

sugar cane/always falling/always wet/always
pouring/always pain/unpredicted/unplugged/
dishonest/unloved.

you are so well read/to be so brown/

enter the negro clown/wasting away his pounds

no one gave it to me

so i made myself like maya
no one taught me i was necessary
so i made myself like malcolm
no one loved me the way i loved
so i loved myself fierce as ntozake

my 7 year old is not available
for any unsanitary standardized test
on your iPad at that!

he don't wanna trace what he can draw
why is that fucking with y'all?

we are mothers
our sons are bored
with these electric squares

can't
find

spirit or warmth

inside there

born inside rings of circles/
pushed out by poems/he already knows/
he is a few hundred years old/mommy i just know/

i just know.

you made me like maya
told me i was necessary like malcolm

fearless as ruby
with ntozake's heart

so, i memorized amiri
and one day i'll recite gil
with a band

told you I wld
make myself your son
with my very own hands.

After Heaven is All Goodbyes

(for Tongo Eisen-Martin)

I would drink the coffee
If it wasn't hot burnt tires
If you swallow gentrification
How many days before you
Shit out a strip mall

?

Or maybe all those hurricanes
Are the Indigenous Burial Grounds

 Waking up.

My sweet tooth cannot survive
The poor people's sugar tax
The "Janky Tour Guide" is the tallest
Piece of Sunshine on this entire Peninsula

Thank God for Mississippi and After School Programs

Still

Waiting.

For the Pacific

to turn into a deep cup of black resistance

Page St. They call it downtown. The beauty is always in
 the core

of the body of the building

How high must the heel be to really get close to

The roof of that empire?

Wondered the woman disguised as poet.

It's okay that he cusses, says the 11 year old magician

He says it really cool, and isn't loud.

he simply lands the mutha fucka correctly

In the sentence.

Ashes from last year's fire make an entrance

The scent of burning flesh

Is sometimes a hot cup of joe

New shoes against a forced blk top

 I'm a language scientist

 Y'all keep placing that rock in my hands.

I just want

One morning without caffeine

Something I can drink to fight this false sunny
Ripping through these cold Detroit bones.

There is no shelter
When the sun is traveling through your veins.
What time is it today?

Light years.

Mixed

I pray
on my great GrandFather's feathers

—the ones you don't respect—
That you never dare call me

Mixed

when i have been a nigger anytime
you felt like it.

I'm from an army of glowing yellow/black princesses
some of us indigenous. we know.

even if the full-blood family don't claim
us.

We all one caste system away from
spiritual death.

i'm mixed.
?

I'm mixed with Moors and anybody from Alabama
I'm mixed with kool milds & sometimes cigars

british tea & southern comfort

Apartheid & Jim Crow

My shoe shine black
 no shield, no mask—nothing removeable.
I've always taken my blackness to dinner
Worn it in the shower, shared it with my lovers

Never asked permission to be who I am
Or changed my voice to fit the description

land the job
not scare away the boys

body still recovering from the thunderous pull of
a Jamaican crowd hauling me

down into their sea of calabash eyes

They tell me
they feel my spirit
in their Treasure Beach chest.

I know you didn't hear it
Your seashell speaker remains broken
or maybe you just

pretend

not to hear my
leveed lips. Water
when it's rising

In winter black girls are bright super moons
waiting for you to notice.
they glow
twice as beautiful inside

infinity

a quiver of cold breath pushes out our bodies
It's winter in america, again;

the subtle sound of survival.
a wolf howls at the indifferent morning
we are always mourning. in black.
we don't choose this pain. these colors.

We swallow our ivory keys
Our sharps & flats, an enharmonic black scream:

Mixed.

The way Ponchai *Sankofa* Wilkerson held a key
Under his tongue and spit it out
before they executed him

We know freedom.

Is just one fuck you
Away from being this poem.

We didn't choose to scrape
samples of our organs back together
sew what was left of America inside

A matted flag
woven beneath the delicate seams of
our children

Born into this madness
Our bloodline threads unbeveled
against each blue stitch

I've worn these scars 'cross my face
My entire life and when you asked how i got
Them, I said

"An angel touched me."

I earned the right to my own damn mythology
What else do we have left
our bodies reduced to all that matters
inside fragile feminism courses.

There is zero removal of this
Nina Simone

| Black. |

My British born, Canadian raised mother
never asked me to

So, why you?

She raised a black girl
Who loved to read; put
Alice Walker and Hansberry
in my hands.

I'm mixed

buffalo & eagle
hampton & hooks
Tear gas & Standing Rock
Front line women & crooks

mixed

holocaust & genocide
horses & low-rides

I survived.

This poem is my proof of life
Your paperwork, never worked.

I understand why you worry when
A drop of blood swims back to shore

Moore babies

|black|

as

me.

Skymiles

The nice chubby white man says "Yes, they do."
Standing on the corner of the red carpet
priority lane at the *Delta Air Lines* gate.

The classism of first class, sky priority and premium status
Fills me up with jokes consistently when traveling.

Another man positions himself in front of me. I am always
surrounded by ugly cow leather briefcases and horribly
 tailored suits
Once in a while, a nice pair of shoes show up.

"Black Women, they do rock!"

He's referring to my jacket I forget i am wearing
"Oh yes, It's a concert I produce, you should come."

"You are a beautiful woman" He says, then kisses my
 hands.

Thank you. I say.

"It's the skymiles."

I Got Life

After 1986

(for Brad Walrond)

> *Snakes inside smokeless cold mornings*
> *Embodies my '80s body*
> *Wondering how many seconds*
> *Before this decade turns in on itself*

I've finally lived long enough to write
31 years ago, something happened!

I was a freshman at Cody High School
Our entire class went quiet

NASA Space Shuttle Challenger
Would last a short 73 seconds

Before turning to fire on live television
The first civilian in space was a woman

Christa McAuliffe
I remembered her curly brown hair fighting

Against the wind as she walked.

A teacher

A two-headed snake of smoke
Choked our hearts

Our breath suspended in air
The actor seemed sincere, convinced the country

There would be more attempts
toward Space

despite the 7 who died on the job.

I would finally bleed like a woman this year

Just a year earlier, I wouldn't be invited to a funeral.
One of my childhood crushes died

of a new four letter disease
My body was changing, slow & deliberate

My crossover was quick enough

Could catch a fast softball at shortstop
My English was Catholic School proper

never had a pedicure or smoked marijuana
a flirtatious/shy confident virgin

I didn't know i was pretty

an awkward black girl
didn't know how to braid hair or curl
or straighten it properly with heat. (still don't)

> Snakes inside smokeless cold mornings
> Embodies my '80s body
> Wondering how many seconds
> Before this decade turns in on itself

Who will become teachers fearless enough to fly
& when will i finally

explode.

I Can't Breathe

(Remembering Eric Garner and Mike Brown)

*Poem written after my time spent protesting in Ferguson with
Talib Kweli, Rosa Clemente, and The Peace Poets.*

I'm in Detroit and
i can't breathe
the air is being sucked out of my city
the poor don't have water
& everything new means

no niggas.

I can't breathe

there is a smoking gun
down my throat with promises of
a post-racial america
i can't swallow the chamber.
it is stuck in 1967
& it keeps reloading after it pierces
the bodies of our unarmed babies.

I can't breathe

cause i'm being rushed
on a sidewalk in the middle of a peaceful protest
by a militarized
police force in Missouri
they are yelling "i got one"
"i got one"

i am half running, distraught
searching for Talib's hand
Rosa is a few steps ahead
the air is thick & ugly & dense

& i can't breathe

i'm being forced to lie face down on the cement
in Ferguson with an AR15 pointed
at my back.

a long brown teenage boy is shaking in Rosa's lap

A young thick girl stands up anyway.
i pull her back down, and ask her to please
 /wait./
In Atlanta a beautiful young activist

tells me she is arrested at 6 pm and
is driven around by officers till 2 am
before finally being booked,
with no explanation.

we know who you are. they say
hoping to replace her breath with fear
& now she doesn't know how to tell
her story of being kidnapped.

she can't breathe

Who can push out fresh air in this country anymore?
the rich? the corporation?
we should all be choking to death from
Fox News, processed foods and white supremacy

My 19 year old calls me
after hearing I am in Ferguson to ask me
to please go home
he hasn't lived with me in years
so i'm trying to figure out the geographic location
of that place.

Home.
the place we should feel the safest.

& i'm wondering where has all this rage been?
when you acknowledge race,
you're called the racist.

Mississippi got-damn Missouri
feels hot as you.
on Can/field
this young man smiles his gold at me

beautiful and bright and bravado

"you from Detroit. you a poet.
i saw you on the news"
this is the place where Mike Brown's blood
turned to roses. the stemmed legs
of our boys. long and racing & always swimming
toward the sun.
easily tripped up

life interrupted.

the ones who don't love
you. are armed.
as much as we claim this is our land
the world minority is running our country

our sweat our women our mothers we
birthed this nation.
built it on free labor and death with
no reparations ray in sight.

Insight.

I need more insight on what this has to do
with genocide.

(everything)

We are here. without choice.
many of us. fatherless. some of us. warm
blooded. west african. dakota. cree. cherokee.
we are a place with no place. we are natives.

beautiful somewhere people.

noosed flag poles and crosses & so many more
little girls plus those 4 we will never forget.

we are moors. portrayed as whores,
criminals. we. the children of royalty
we red clay goddesses. we down south forests
we the trees with rings of stories

i can't breathe
I'm home
from a terrifying place
an octavia butler past/future
past lives scars resurfaced.

i can't breathe

my son is four years from 12
& the park is his own planet.
where he plays freely
and he knows a seed leads to flowers
if you plant it.
he loves bob marley faith ringgold and frida kahlo
walks with his head up & doesn't follow
recites baraka
sings the blues
he thinks wearing a belt is cool.

he is simply a black boy with an imagination
built on nations of poems
and a mom that says
don't mess with me
cable is a winter luxury
so we don't get our information from the idiot box

i've already had to teach my son
how to act when we are pulled over by cops.

he's seen them wave and like my poems
he's seen them black & flirt and ask to
call me on the phone.

he's seen them white in dearborn heights
accusing me of running a light i did not run
"mommy, but the policeman is lying"

this is the reality too son.

when i can't breathe
i cry. in a parking lot
dropping you off at hockey camp
praying the white coaches & white kids
won't try to suck the beauty out of your lungs
pray you black ice skate fast past the chokeholds
the dangerous walks from the store to buy candy.

i can't breathe

so i rush
to get you from school daily
a collective mother's intuition always

feels death moving
round this winter in america clock
in these spaces where the air is thin
humanity is forgotten
& ancestral spirit is blowing hard
& fear has pushed you to a place
you don't recognize.
a forced language is pushed
into your mouth
whipped across your back
along the ivory coast
on the ship called jesus
in the Congo
through the door of no return
in an Alabama cotton field
in chicago in cleveland in staten island
when you look the world in its face
after attempts to hijack your spirit
take your breath loosely

for a loosie
I will inhale God & blow my last wind into your body
your exhale be the holy ghost
for this land.
i can't breathe
i can't breathe

i can't breathe

i can't breathe

i can't breathe

i can't breathe

i can't breathe

i can't breathe

i can't

breathe

i can't

breathe

i can't

breathe

Breath

Amazing Grace

Some can sing,
Others Summon
ancestors

at will.

Aretha lives on.

Black. Ice. Bodies.

*(for Debi Thomas and Alicia Hall Moran, after her show
"Breaking Ice: The Battle of the Carmens")*

1.

I was pre med. fresh. Stanford.

I was a refined black girl magic.
I was gold, already. Ask my mother,
Janice. I was born gold.

With killer smile &
strong beautiful
legs.

I was trying desperately to concentrate
I didn't feel like i could
I don't want skating to control my life
You gotta make yourself happy.

Maybe your body will just do it

Maybe you will backflip and land on one skate
Puzzle them by doing something that has
Nothing to do with them, scores
or ice.

How dare you be that unapologetically black. Girl.
?
They call you a rebel. rebellious.
A trouble maker.

Don't bring all that honesty to the ice.

You gotta represent. Pretend those scores
Ain't low.
You know those scores are way
Below the mason dixon.

I just want to hear one, "beautiful"
For one brown girl surrounded by all that
frozen, white.

I want to hear one, "beautiful"
From one white commentator.

A gorgeous.
A stunning.

I want my dark lover in the audience to have
 a close up, as he admires me and promises
his own gold, if I don't win.

Now, that's a love story.

Let's see it.
Let's hear it.

How many times have we heard this non story
This disappearing this melting of spirit this madness

Oh, yes, that is dark beautiful mother
in the audience. Stage left.

She wants the commentators to applaud Debi's double
the way they saw the same flawless
double, that was a double on Katarina

You see, we must
triple
their doubles

Contort into something unrealistic, unreachable

Stanford. Stay firm. Study Hard. Don't fall. Balance.
You can't be average and brown and girl.

That won't do.

You must absolutely dominate. Always.
This is not a pretty sport, despite all those pretty dresses.

2.

Ask Mabel Fairbanks.
Scorpion child in 1916 Harlem
Black leather pawn shop skates
Stuffed with cotton.

Turned ponds into city Olympic stadiums
Not allowed inside to skate, not allowed
To practice on public rinks.

Taught in private. She created her own
Ice shows. Coached and taught the next
Ones how to grow & skate alone.

She skated with me
She felt the trauma inside the freedom
The pain with every push away from the edge

3.

I'm skating to Carmen. It's an Opera.
It's not like we are wearing the
Same prom dress.

Katarina.
Beautiful. Gorgeous. A Natural Beauty.
She was crowned queen before the bow.

They said/I had/a street smart musicality
Is Katarina not from the streets of East Germany?
Does she not have a street smart musicality?

These are not shell toe Adidas. This is not black top.

this is black ice

I didn't take Carmen to the East German corner.
This was not a breakdance beat down in a Brooklyn
Alley.

This is figure skating.

Go figure.

I should feel pretty
good about myself.

Not proud, not invincible, not bad.
She said "not bad."

 I was just okay?

How many triples equals feeling pretty good.

I am on fire.
I am ready to just be a student again.
Become doctor, an intellectual.

My soundtrack, black excellence.

4.

I am not beautiful to the watchers.
I am the rhythm. The misunderstood

There's nine judges. The highest scores
were given to me by what is called "The Thomas Team"

The US and JAPAN.
So, they don't count to the watchers?

The word beautiful is used dozens of times
To describe Witt.
Gorgeous. Paaaaainfully
Gorgeous.

The East German woman is now
en Vogue.
Great eyes. Great features. Beautiful hair.
Overpoweringly beautiful.

5.
(Katarina Voice)

The watchers tell my story.
I get thousands of letters from boys
At least one US ice show has offered me
Millions to skate when i retire.

The "posing section" of my long routine
was met with great admiration.

They say I have a future, bright as the sun.

She dies at the end, I think. (Voice of Debi)

Witt continues:

I wanted her to fall.
You don't ever say that aloud. It's
Horrible to think it.

But i did.

I wanted her to fall.

6.

Maybe your body will just do it

little brown girls take their hot hearts
carry them to the pit of the coldest places
unrecognizable love travels through their
veins, freight trains
abandoned passengers
get off

on their pain.

heart and spirit sometimes grow tired

you just want to skate. to win.

heart is tired. spirit is unsure.

Maybe your body will just do it
Maybe your body will just do it

find a way out of the war that was only about love
for you. find your toes connected to spins
catapulting you into the next galaxy

you don't feel like showing up
The high five with your coach
is off.

We missed.

maybe your body will just do it

Maybe your body will remind you
Sometimes skin forgets it is layered
With flesh stories. bones breaking

When simply walking
Truth & teeth & mouths
taped shut while speaking.

Just skate. Just ignore. Just pick
Up your flowers. Just be grateful.

This body is a landmine
Full of dividing lines
Waiting for you to walk over
Or explode into pieces
If you violate its
 space.

watch the steam rise
lace them up against the screens
We are all counting on you Debi

simplify the fear

It's all psychological.

7.

My mother is not happy, obviously.
I don't think i landed it all year.

triple toe, double

Your body will spend the rest of its life
Wondering when you decided to disconnect
Disappear
 from headlines.

It wasn't supposed to happen. i tried.

Will I skate in the next Olympics?
I'm still in *this* Olympics
Why do you need to know
right now?
The answer is "no way."

I'm still alive. I can get on with my life.

Invincible. I'm in/vin/ci/ble

I wrote it on my Stanford application.

8.

My freshman year at Stanford
I win both the United States National and
World Figure Skating titles.

Gotta simplify the fear.

Are you scared of me coming back?
I want to ask, but don't.

Invincible.

triple toe, double

Excuse my stage manners
I'm not a polite barbie doll
I rebel.

triple toe, double

like my unruly thick hair

9.

Can't you see this little light of mine
Can't you see her holy ghost and all
Her forgotten
trinity sisters getting
In a 1988 freezing cold formation

They skate with me. Maybe this time
They can skate
 for me.

Maybe my body will just do it.

Turn invisible so they can see how
Beautiful i am
when i walk up 125th st.

6 revolutions in a split second

double dutch hopscotch cartwheels
brilliant just brilliant

The low scores began at 9
It begins early. The fight of your life.

To simply exist as a full human

Ain't I a woman? Ain't I Poughkeepsie fine?

After i landed my first two triples
The rhythm of my jumps received the credit.

The rhythm made it easier.
So, technically blackness is a technique
So technical it makes your jumps less
Spectacular.

Of course you can Jump.
Rope. Hopscotch. Cartwheel. Double Dutch. Skate.
Fearless & fiery. Black ice skate with ease.

The commentator said I should "feel pretty good about
 myself."

Settle for silver. In 1987. After a standing ovation.

Settle for silver.

I'm just relieved that this is over with
Scott Hamilton.

But it's never really over for us. Scott.

Is it?

I can take off these skates

but the rest of me

Triple Toe, Double

Stays.

Aretha in August

*Aretha's voice is what God sounds like in my city. She is the
sound of a black jesus holy ghost chased with hair grease and
cognac. The smell of granny's sunday breakfast, pressing combs
and tindered scalp. The beat of every little girl's holy broken
heart. A symphony of gospel, gunshots, pool halls, police sirens,
protest, rebellions, vinyl records, and late friday night basement
parties. A score conducted like the first time a girl feels like a
woman in full control of a bedroom. And even so always, love.*

Her voice a command of conjure defiant and soulful.
Her pain collected Ours as a people, as women.

*Aretha was a teen mother, and she struggled with things that
 all women
before their time struggle with. Women who unapologetically
 walk in their power,
balancing the men they love while still loving their own damn
 bodies.*

*forced
to get on stages all over the world
smile and sing despite quiet, personal battles.*

keep our stomachs flat
our bodies tight like little girls.

Be the entertainment—even when sick or simply exhausted.

Arethas's discography was the rattling bicycle chain sound of
* my childhood in the seventies.*
She was the familiarity of future divorces and the chain of fools
I'd fall in and out of love with as i became—in my own right
—a voice in the World.

A voice that often made men—who were not whole
—shadow in my light.

(for the Queen)

Detroit. Home of soul. Gave birth to a voice
Skies bow to her sound in flight
Pink cadillacs line the street.

Preachers are talking. Women are wailing
Trying desperately to hit your unreachable range.
Singing is not just an opening of a mouth
It is a deep sinking into
a blues. A conjuring of spirits

Gotta find black angels for this type of taking over

Our gray city
earth shattering quiet this day only a slither of a scream
Air thin as industry the voices of millions of women
encapsulated inside one throat

All minks must hit the floor one time
to prove they are Detroit
real. born. shooting.
Giving them
something. they can feel.

Break their hearts, first.

Sparkle when tired

Sing so new tongues recognize

the salted taste left behind

is the sweat

is the soul

of a Queen.

on memory

(for Jeff Mills)

1.

Why do you write about the
Right now

?

The right now needed me.

2.

The universe may not have time to write
You into existence.

Ink just might be thicker than all that red
Alive in a blue vein.

A one way fast train
a future backward destination

The alter ego of one child's imagination
could be the answer to

The greatest equation.

3.
Are we really out here?
How do i know the sound i hear is the sound

You make?

A constellation of questions
A body of people parading

the streets a lunar eclipse of a face

Smiles at the indifference of the right now.

Maybe if the sun has her way
Too hot to get close to
Is there a liquor store next to the halal pizza spot?

4.
We a body of mirrors
We a bootleg urban fiction narrative

I recognize your character a few inches to the left
Of your story

What else do we have to give
What was given to us, stolen, replaced.

Who else to conquer
But mirror.

Fear is a learned skill.

We are all out of definitions for the
Impoliteness of colonizers

Please and thank you

Some things don't need to be said
Joy road is still searching for a good Wi-Fi signal
Or maybe a bike lane to tomorrow
Our salt is in our bones
Bends over knees, grows our feathers
What to forget
What to take with us
Who we leave behind

Our palms, a constellation of maps
Promise, undefinable
Heart is the color of God/dess
Eyes replaced by stars
No breath between thoughts
No curses cover this air

We become the language. tangled spirits
Small talk only among tall trees
Who are we

 ?

5.
The unobtainable.
The beneficiaries
A lover's fight will not travel to
This place. Weightless

perfect blend
sand and salt

What is the song of the living?
Humanity's anthem. rebellion against mediocrity
Only the wise young know the truth

6.

Tomorrow is an understatement
Ever after: a disguise

A body of clocks with no feet, no heads to explain
Fall bending into sound

Less time + Memory = yesterday's promise to stay

So, where should you go
to find unbottled water

asked the tears.

Is this black hole
empty, a shelter?

For less homes & more people

Have we finally become found?
Dug up by future Afropologists

7.

Smiles underneath a fantasy
Movement women

—delicate stories swimming beneath

skin & bone.
structure, to build a strong home

a place to simply exist

We born again
Wings are too cliché
Stillness is the new way to get there

Fast.

Covered in lotus
A gown of coiled green stems becomes skin

We umbilical cord
First breath
Occurs every rise
son. Morning is a thing of the past

(silent)

Twilight is.
we can't speak what doesn't exist
Into existence.

Suspended in memory

You know this dance
Ancestral information
DNA as dialogue
Pass it up—never
 Down

Trance/Atlantic
Be specific about your source
Resist double tongued transmissions
Or Reflections void of nuance
Recognize
pain

Is work, is sweat
Is not without hours of joy

Reality is the third tiger's eye of the
Beholder. Our history wears around
our neck when backs grow tired.

She is an ocean of fish and no oil
Healthy polar bears and iceberg slim

Some of us forced to swim
Before cosmos were cosmopolitan

8.
Our babies born with steel fins
Our stories sonic jazz of gil
Funk always finds its way to the protagonist
 Recorders of bees
Protectors of flower nectar
rhinoceros horn
Opposite of extinction
Indigenous resurgence
Laughter a simple prayer a crossing over

Children are the new Gods

9.
Elimination of speech
Talk through touch

The crystal city is alive

Ask the Owl ask the Black Elk

Men will one day see things from a woman's
Perspective & name it
Vision

Language of the forgotten
Language devoid of spirit is an un-universe

Still
black hole on the inside. On purpose.
Find your purpose. Endless.
Grandmothers, moon-dipped fathers

Facing earth
No more sons disappearing to an impossible narrative

Foreshadow your freedom. Chakra map your body
the question lies awake inside your chest

East is west, backward
So now the tribe is lost

Come past compass
Come through
Makes a michigan left

Hide your heart on the right
Fighting clocks won't stop our pace

Never waste beauty

Speed of light slowed down
For civilian conversation

10.

A century of stories
In one sentence
An utterance an indoctrination
A meditation
Broken down into minutes
A combining of seconds and syllables

Alphanumeric tongues
Slavery is not a word, it is an amalgamation of evil.
Chains transferred into trains, escape routes, parted into
Little girls scalps. Braided memory
Which part
creates the maze of confusion

Avoid this road. Cross this river.
Eat this math. Align yourself with forests and
Compare your royalty to no one.

Arrogance of air?
Bling of Mars?

Only oxygen is omnipotent

Hold onto your illusion
As long as you can

Convince the world the sea is blue
Sometimes blues are necessary, in order to see.

Inheritance is not safe
Is not protected
Is not for sale

What will you sell to receive it
Who will you deny, colonize, build over?

In order that you walk.

free

?

II.

What else do you have to give more valuable
than memory

Mouth full of red clay
Spine exhausted
Imbalanced passage down the middle of our backs
How do you think you
got here

?

Do you know how to get past

it all

Why settle for the right now, girl?
Don't you see yourself in all those stars?

Some choose to forget
Others feed the pain
to their children

The beneficiaries
The storm inheritors
What is your sacrifice

?

Your name.

Origin of everyone is

Diaspora

We Were Born Moving

(for my city and my daddy, T.D. Moore)

Originally written for Ford Motor Company TED Talk at Joe Louis Arena. Marion Hayden played upright bass. Joe Louis Arena will be torn down or converted into something "new" in the future.

We were one in 5 million
migrating
toward the north
To find work, for opportunity.
Fathers, grandmothers
140 trains arriving daily
A place known as an underground railroad stop
Across the water from another country

Our birth. a starting line
Our journey constantly evolving

We were born moving
Breaking rocks and racial barriers
Leaving a pathway for the ones who
came after us.

My father came from Madison, Alabama
Some left Mississippi or Georgia
Traveling somewhere people with faith
In their stride, pride in the tilt of a hat.

Sometimes you must move with great intention,
with force, with tears, fiercely into the unknown
 in order to survive.

Dreamchasers built Detroit
our great city of possibility
We are the children of the up south movement
we are the bold aortas
Those left ventricles, gear shifts
Pulmonary arteries are pistons transporting
blood from the right ventricle

You must search for breath Under the hood Inside our
 chests
Those arteries are connecting rods carrying blood from the
 heart
The gas that fuels our machines that drops off the
Most important little people in the world, to elementary

Schools at 8 am every morning.
Imagine the body of our car as a body of a people
Painted with thousands of extraordinary colors

Mufflers as lungs
Pushing in and breathing out the beauty of innovation
The complexity of history
The necessity of technology
And the simplicity of that
Road trip you keep dreaming about.
our bones, an assembly line of interchangeable parts
Our legs fought against segregation
our arms reached for jobs at Ford Motor Company
in 1919

a metropolis of ideas,
our minds
the workstations of the future
how we get there and who we bring along for the ride
will be the marker for how history defines us
everyone can't fit in the passenger seat.
some of our families are larger than a sport utility vehicle
our aunties need a ride to work

we've adopted a few children who must stand in the cold
to take the bus or walk to school in the cold winters
of America.
humanity is not just oil, it is blood
it is the amazon thrust of traveling
stories beating,
speeding at 200 revolutions per minute
we the economy of black gold survivors
a highway of stars shine bright as our rims
an expressway motor city of tomorrow could include
making room for bikes &

Carpool lanes or an express train
That can get citizens across our *glove* with ease.
We are the hope and the heartbreak
A fast car with no brakes
We are the old school cutlass
the cadillac the focus
We are the prom date
And the first kiss
We are our ancestors'
wildest wish
We were born moving

Mobility is the ability of Aretha to reach that
soul note and Smokey to rearrange our tears

to know our city is built on love and project

window wonder men and supreme women.

the holy ghost of alice coltrane's harp

The power of marion hayden hands flying down her bass

follow that sound on your favorite satellite station

move closer to what really matters to you

when you pull out the

Driveway in the morning.

press down on the pedal

put the top down. expand your ideas past 7 mile

Put the joy back in joy road

My Detroit block that included libraries and schools

in walking distance

our global city created the first highway

There's no reason we can't create a safer way

For our families to travel on top of them.

Who else to design the transportation

Of the future

Than the most resilient workers

On the planet

?

The rewiring of humanity needs humans

Requires delicate components that connect people

With luxury and dreams
The way immigrants and migrations & sweat created
Our automobile empires.

Transportation should never be a reason
students can't get to school, or stay
Late to play on a sports team, because
The bus line isn't safe and mom works two
Jobs.

If we can imagine a car that can fly,
Past all our great expectations.
Then we can imagine a world where
Race

is only about cars.

Detroit is the starting line of the world's imagination

But it's not about how you start the race
Or the sacrifices you made to build your life in peace.
It's how you find a way to push victoriously
To the finish line and while crossing over that white line

You consider the value of a
Speech about a mountain top

An engine
As a heart

Mobility as a right
Like breath, like water, like freedom

We only get there
When every piece is moving together.

Where Are the People?

(for the bodies we can no longer locate)

Where are the one way tickets
Who signed the death certificates
Where are the magicians, the madmen, the toothless,
the smoothest, the poets

?

The corner store prophets.
The bus stop historians
The traffic stoppers
Where are the people?
Where are the blues
Under which pile of gravel
Where are they buried
Hurricane Cass Corridor
Where is the soul, the soil, the socks, the soles, the shoes
Where is the heroine. Where are the pills
Where are the women. Where are the thrills.

Where is Cass Corridor?

My students ask:
Is it a building? Is it this way
is it that way?

Your school is sitting in it.
I answer. YOU,

is it.

The dogs are walking the people
the dogs have parks
the parks don't have children

Where are the people?
The stepped over, the forgotten holocaust
The fragile, the beautiful, the fast talkers,
The backward walkers, the 3 am stalkers
Where did they take them.
When will they return
Where is the balance
Where is the money
Where are the schools?
Where are the people?
We all got Wi-Fi

nobody getting high outside

Where are the beds
Where is they heads?
Where are the recognizable street signs
Where is Joe Louis?

Where are the black people
My white neighbor asks me
Where are the black people?

Where are the chosen people?
Where are our hearts, our guitars
Where are our bass players
Kenny Mac/Anthony Tolson
Rest in Peace

Where are the anointed ?
The children of God/Where is the sage, the holy water

Where is the black imagination located?
How much does it cost per square foot
To rent there?

Is there a rent to own
your black imagination option?

Where are the couples fighting in the alleys
Where are the purple flavor Mad Dog 20 20 labels?
Where are the needles
Where is the good time

Where did all these gotdamn bike lanes come from?!!!!!!!

(silent scream)

Where is the line
to simply exist
 ?

Where is the painted line
to live to breathe
Where are the parks with swings?

Where are the children supposed to live
Where are the children supposed to run

Where are the twilight teasers
The moonlight mythology makers

Where are the military vets
Where are our mentally ill

Where are the people
Where are the people
Where are the people

San Francisco
Oakland
Harlem
Detroit
Chicago

Do you know?
Do you know huh?
Have you seen them

Did they all die so New Detroit could live?

Where is your conscience
Where is this nonsense (coming from)
Where is humanity
Where are the people?

The one way tickets

The message is still in the bottle

Where are the indigenous where are the salt mines

Where are the people Where are the people Where are the
 people

?

?

?

When you find them

Please tell them

I have an overpriced gentrified cheese & pork pizza

With their names on it.

Tell them, I am writing for them

So they won't disappear

without a fight.

Black Is the Color of My True Love's Hair

Dear Ossie, Dear Ruby

Dear Ossie, Dear Ruby
Do you still put roses in her hair?
Do you still draw the clouds, and fluff them
for her head
?
Is the sun still sleeping in his eyes
Is heaven a place along his chest
Are you resting in a timeless embrace

Do you still make her laugh
Does it still matter
?
Do you hold her hands—diamonds
hidden inside palms from fingers.

Is eternity inside his kiss
Do you tie his tie, adjust his chapeau
do you dance, in the morning
Do Amiri and Maya and Jayne and Gil and Sekou visit
to drink grapes & share stories
?

Dear Ossie, Dear Ruby
Some of us dare to be the exception
dare to be conductors of black love
Do you still, love to be
still.
while the world travels at full speed
how glorious to watch our attempt to
become the black doves you became.

do you still fly south for the winter
pick pecans & eat round sweet cherries
on a long wooden porch.
?

Dear Ossie,
thank you for your kind words in Harlem
when i nervously shared that Abyssinian stage with you

Dear Ruby,
thank you for your fearlessness & hard laugh
In the lobby of the Schomburg
"I slapped Denzel Washington
in American Gangster. It wasn't in the script."

you told me

I can hear your beautiful stutter—planned pauses
Land gracefully on your tongue.

eagle woman.

The morning of your funeral
I'd spent the evening celebrating our sister
Sonia Sanchez's 80th birthday. I watched her and
Haki get in a car headed to Harlem.
I was in so much pain from losing Amiri.
I wasn't ready to bury another legend.

Forgive me.

Dear Ruby, Dear Ossie

We know we are possible
we know we can be gazelles
on a planet surrounded by wolves

Is his voice the sound of water
Is her smile the perfect moonlight

Do you remember
when it was all a dream
?
do you still love to get on your toes
to reach his nose
kiss his neck
Is she still your Juliet, in a Spike Lee Joint
Is he still Da Mayor, Mother Sister

Dear Ossie, Dear Ruby
thank you for loving us.
Thank you for loving each other

we marvel in your reflection

thank you for your life/work.
for your voices & bodies as gifts
now that you are true stars
Do you know
you were
our
greatest
wish?

Love, Jessica

the magician's mother

The magician's mother says
Make him appear

Love.

Turn my legs into ladders

Ace of Spades
This altitude is breaking my breath
Lean in and kiss his gangsta. His unruly beard
Resting against your cheek

What's wrong with a woman who gets
Turned on by his willingness to take out
The man near her passenger side window

Romance might need redefinition
Detroit definitely in the water of her blood.

Alice Coltrane at Midnight

Driving up hills that only lead me
to reality

She never wants to leave you
he leaves so honestly

In a poem

They make love countless times
In a poem they are black Bonnie & Clyde
Shooting mics and stealing ink for new pens

In a poem
Amiri Baraka is alive
Giving them his blessing

Magician can't make fathers who call
Or soulmates who show up in correct decade

Hearts disappear from the deck

Somebody made the rabbit a late night snack
Poet decides to withdraw from the ongoing
Romance novel in her brain

Draws herself a blues

Plays a Robert Johnson record
Decides, he ain't ever gotta touch me
I know what electricity feels like
From a cool distance.

I am not half of a moon

Four years from fifty
Doing the math on giving him a sun
He is that beautiful
Said my high heels

Wonder & Smokey

Just enough to make me want to
Inhale a clove again

Just enough to wrap this Supremes
Holy ghost Motown sound
 round his waist

Handclap replaces the rooster
She too chicken to tell his long arms to hold her

The most memorable moments are temporary

All those hours on the unnamed renamed peninsula
Collided with a helluva lot of magic
Birthed a few new poems

no tricks

All in plain sight.

for one of my lovers

I don't know how to operate
inside long silences.

I still love you
For the infinity

We create.
It never stops,

But, somehow, you do.
I pretend to be free

To not need to come home
To a man anymore. After

Two dresses and wildly large
ceremonies, why would i want
Such a thing?

I love you

You said it.

First
perhaps as a dare.

I will love you

last

My clumsy heart, oh how she slips.

Monk Moore 11.7.17

The problem with loving a poet
Is that she is falling in love with you
Before you felt the delicate push,

cool one.

When your eyes told her a
story 'bout your child

hood.

In a fine black hat she swears you stole
From her collection.

She is not waiting around for you
To catch up. She is already filling a bath
With jasmine oil and leftover petals from her 10th
Birthday.

Poets don't need long engagements
They know if they want to have sex with you

sometimes or every day or absolutely never.

They recognize the language of someone as
Smart as them. This is what will keep her

Listening.

If you do not know who Thelonious Monk or
Amiri Baraka be, then you should probably
 Not
pursue said poet.

The problem with loving a poet is she never
Stops loving you, even when she says she has.
She may hate you, but she loves the poems
You inspired. The smell of the food you shared,
The hardcover books on your shelf. The time you
Held her hand, took it, confidently to protect her
From some busy street she was never afraid to cross

Alone.

She still liked the way you took it.
Somebody gotta walk like a man.

If you make a woman laugh, then you have extracted fire
 from smoke.
If you make a woman poet cry, you will be possessed
If she wants to talk to you, even when she needs to write

You have crossed the red sea, dear brother.

You have summoned the magic of Pharaoh's army
You are a tall believable Prince, with a velvet syntax throne
to lean your
Chiseled brown back into.

The problem with loving a poet is you
Will find yourself kissing her gently between her lines.
You will find yourself in places you never imagined
What an Ugly/Beauty
The Mister/ioso Album Jacket
A Harlem corner, a relentless Detroit winter
a Chicago Lake Erie chill.
or maybe right here.

Discovering who you are
inside a page.
Finding your soul the brief moment she takes a breath
Before delivering the ancestors back to life
Through a song.

When her heart & gift are open.
the poem

has finally begun

Monk Moore
Love is the most honest
& sexiest
prayer
position.

Holy Family

Dear Black Madonna
Dear sacred mothers
America is coming for our sons
with AR15s

Just as they came for Jesus.

How many crosses shall we burn?
50 years after Detroit and Newark set fire
to racial inequality
& police brutality

How many die before we erupt?
Our children, blood-lava, spilling on concrete
jungle streets

how many prayer mats, face east and pray
5 times a day for relief, for sanctuary, for peace.

I watch my son's arms grow longer
I listen to his mind strengthen, his pride

push past America.

What is a slave name?
he asks me at 10
This is the moment our sons let go of our hands
& want to play in the park with friends or walk home
from school alone.

The answer is:
Tamir Rice will never

This is the collective worry of millions of Marys
hiding their Jesus children in the shelter

prayers, blankets, candles, family dinners.

Our sons, still burning
Our daughters, not safe

We rebel against colonization
Resist the death of culture

The killing of the old
To rush in the new

One day a prophet shall return
The Flint water turns to wine.

For Gwendolyn Brooks

a crescendo of little girls
affording themselves an imagination
line up for the front line, polka dot
dresses, striped ankle socks & black
shoes.

they watch the world from this place
they've been told is the battlefield
they only know what their stomachs
have told them.
their hearts connected by a thread of
courage, men have yet to own.

she is hungry for a language
she won't want to turn into waste
a freedom that only a Gwendolyn Brooks
can offer.

these girls, classic black oil
standing in their own mythology
armed with poems, pressed into
sunday curls & pink nail polish

Blues have not found their way to them
sorrow is for the old.

they have found poetry so fierce
can't be contained inside their bodies
no casket can bury capacity

So they laugh and giggle and smile
and sometimes they are quiet and mysterious
as half a moon.

a constellation of poems live inside their wombs
waiting to be born again. a ballad of wounded
birds flying between their bones.
assembled by a whistle, manufactured by a wish

Foremothers

Who gave their lives for craft
Insisted their voice include their throats
unrooted dark silk flower, still growing
from original, rich diaspora; soil.

Brooks gave us all permission to blossom in
the belly of unforgiving acts.

She told us the light eyed and the dark skinned
are the stars of our DNA.

our hearts, a gold dug too deep &
mixed gently with fire and blood.

Brooks taught us, flowers are not to be worn
to simply mourn a death. they are an extension of
the living. their branches form from our mouths,
the seeds of our thoughts,
our actions.

So, live on Gwendolyn Brooks
Queen of 100 races around the sun.
Purple Hyacinth buried inside your afroed coif.
We are grateful your typewriter located our perfume
walking past,
your second floor apartment
in Chicago.

Your poems attached arms and legs
& complexity to the rhythmic souls of our walk
our pool game. our death traps, our cool
personified.

live on, peculiar cactus
in this dense desert of cement.
write on, among the angels, Ms. Brooks.

We understand.
our pigtails & lace dresses
hide stories as bombs
waiting to be discovered
or explode
depending on the weather
or if granny cooked the greens,

just

right.

coda

Gwendolyn Brooks.
Gave us permission to return
from the uncertainty of the frontline

quickly push off our shiny black shoes,
find the familiar grooves of a slanted

oakwood shotgun house floor.
rush to find a table, a piano top, a dinner napkin

take a moment to laugh

& remember

to

always write.

Vertigo Woman

(for Sonia Sanchez on her 80th Birthday!)

we
are all
spinning while standing still
all at once. us.
vertigo women

birthed from the cosmic afro
futuristic tornado wombs of street corner
theater & Paul Robeson baritone
deep guttural alabama DNA
tested for being the temperature of the
equator

on the 9th day of September

Sonia Sanchez turned 80
& that is very hot.

you have rescued so many of us
Under a Soprano Sky—us—
blue black magical women. from

the bowels of mainstream beauty.

we sistas dreaming just to be loved
honestly. with the nose & breasts
and lips we were born with.

to be safe *in the house of a friend*
our internal wounds salted & licked
by exiled wolves who spirit-kill women.
who read books.
who create sanctuary

in their own home. who find joy
in the discovery of their own bodies.
like the singing coming off drums

u allowed us our own image. as
necessary mirror. as template. as model. everything is
not a thin, collapsed american nightmare. you promise.
this is not a small voice. while holding our dreams
in your throat.

cocoons turn to butterflies when you speak
you told us there was something left behind
something priceless we could spit out and shine off
& share with our daughters.

something they cld never silence.

poems.

you have pulled us closer to our ancestors with grace
you made them more accessible. you literary goddess
in a den of language thieves.

a fortress of love. a ginger tea
a warm miso soup.

you break the sky open with
your sunsets of peace

pull haiku from your curls & carry them
as children. say them backward sometimes
just to see if the story ends the same way.

there is balance in all things.

shake loose our skin so the mask is
no longer necessary.
make it wearable art make it glow
your poems blow so we can hear how trane
wld have played it

your poems laugh
so that we can recognize malcolm's smile
on the page.

you challenge us to be human
to become who we say we are as a people.

you are a giant among the dwarfed ears of
misogyny. our feminine genius. our sister.

sonia who is the color of Bahia
sonia who is the silver panther matriarch
of black art
sonia the pantheon of poetics

a structured sound of meter mixed
with machete. rapid fire brilliance
& soft warrior resistance kisses.

she loves us. and it makes us love
us better.

sonia gives us permission to live
aloud inside our magic. to not be
confined to definition and taught me
to own the space i was in while i was
in it.

bits of pieces of us all over the planet
become whole when we discover you.

one poet at a time.

the first time i found you, you saved my life
from the narrowed curriculum of my Detroit Public High
 School
you were there, sitting on a library bookshelf
with audre lorde and ntozake shange and lucille
clifton and alice walker and toni morrison & octavia butler.

confusion & displacement & cultural abandonment
was lifted from my 16 year old body
i had mothers and they spoke in beautiful tongues
quick wit & metaphors

I've Been a Woman and I know *We a BaddDD People*.
when we have fallen into our collective
depressions. when artist paranoia is
at full steam. when we just need to
watch a comedy to boost our immune
system.

we open your books. we find your heart.

when our last lover has been swallowed
up by insecurity. when we don't know
how we will make it through winter
on poems.

we call on your hand grenades. we conjure
your sonku spells. your eyes closed
going awayness.
your hypnotic chant. your exalted whispers.
your self love walk around the stage stance

if she loves you, you already know you
need apple cider vinegar, raw almonds and coconut water
on the road. that you must find the food
that will hydrate your soul so u don't run out
of energy.

so we can continue to continue

in the spirit of langston and maya and baraka
and ruby

we. resistance community.
women, educators, mothers,
together, at our seams. you hold us.

it seems surreal to share a conversation
with someone who took words and made it
global testimony. called on poets from around the world
to wrap a city. called Philly. in something called peace
in the form of haiku.

chalked on the sidewalk peace poster at the bus stop peace
mural against red brick peace internal peace
single mothers' peace our brothas for peace

spinning while standing still.
you

Vertigo Woman.

with twelve hands, twin babies & fire water
your poems are our secret ammunition
when they mispronounce our names
on purpose.

our conscious
for some women
who sell their baby girls for the high

those women who loved Malcolm

who understand that language is weapon
& tongues are sharpened swords.

in Jo'burg I watch you quiet a room in seconds
when the stool is not tall enough you walk away
from that podium.

and we see you. this petite lioness
commanding every breath in a space

reminding us we have to still fight to be taught
our own history, our own writers, in our own schools.

does your house have?

Sonia Sanchez.

does your house have

peace of mind

?

does your room spin
when sonia enters?

does everything seem clearer
once you have her in your reach?

sonia. we in brooklyn. we in detroit
we in oakland. we in philly. we in london
we in south africa.

we spin for you
we flower bed community
safe place for you

we will catch you
when u

need us

too.

Gratitude Is a Recipe for Survival

Ntozake, I was able to send this to you before you left us.
I am so beyond grateful for your lifework. Thank you.

She is the woman in yellow
In her kitchen full of teas and fresh herbs
She is cutting celery for soup and a slow fire
Warms a broth that will leave her doctors in awe

She is cancer free, and more fierce than she was
When there were two breasts to define her as

Woman.

arms stretching
Daylight so the nights feel less heavy.

She has decided to live, despite the post-traumatic stress
Racing through the veins of so many of us.

Warriors. Survivors. Artists.

Who break poems in half for decades to feed an audience
But must budget food for our children

Self care is not a catch phrase, it is simply what is
Necessary when you aren't poor enough for federal
Welfare or too rich to realize the pharmacy is not
The answer to all your darkest fears.

Some mothers just need to be prescribed some
Sleep. Or the power to fight against the chemical waste
 polluting
The air of low-income neighborhoods.

Magic blue/black women who turn 25 floor project hallways
Into endless playgrounds for princesses in pigtails
whose deferred dreams turn every corner
Defy gravity and define possibility.

 One part honey
 Two parts ginger

A Grandmother carries nearly 20 grandchildren in her eyes
She will not be easily moved
by the lead infesting her reality—the poison
Water she has been cooking her greens and bathing her
 Flint babies in
for years.

She is conjuring the chefs of gutted pigs
The salted seasoning of slavery
The ancient healing remedies of
Moonlit daughters and Twilight fathers
Who decide they will not die

Today.

The courage of thousands of displaced
black american HIV-positive teens
Fighting for their lives without
Shelter from a pandemic
no church
no place to provide adequate health care
Or safety from stigma
Pushing for resources and representation
In a country
Where healthcare is only for those who
Can afford it, not the ones
we can no longer
afford to lose.

 A dash of cayenne
 A squeeze of lemon

An american toothache laughs
at the sugar tax of San Francisco
Comedy is a consistent remedy to
Boosting our fragile immune systems.

Where u live determines
if you are treated
& how
you are treated.

Still, Here I Stand
Metaphorical Daughter of Robeson
Holding my 11 month old son
In my arms at the DHS office.
The student from UofM
Recognizes me in the line
despite my baseball cap
and jogging pants.

Turns to me and says.
"We are studying your books in our English class"

The homeless man gives
my son a dollar.

I am hiding.

Hoping to not look like i'm doing well
Doing well doesn't go with the chairs in this office
I'm thankful and embarrassed
The same day I was booked for a show in Paris
asked to deliver a Keynote at another college
My son's health insurance was canceled by the state
and the preschool says i owe them 3 thousand dollars
Before my son can continue
in the new year.

The daycare lady is asking me if i have a job

Again.

I am a famous poet and writer.
I've performed all over this country
Europe, South Africa, Brazil. Ghana
Remember me?
I was on the cover of the New York Times
My poems are alive on the 4th floor of the National
 Museum of African American History in
 Washington DC
I'm on display
Always on display
Exactly what does being a Legend pay?

I need some W2s for this life.
This is madness i tell myself
In order to receive help from the "state"
You have to be working.

My writing is my work

I can't have my son 24 hours a day
And write and create new work.

Question marks float on top of the head
Of the case worker

Herbie Hancock plays in the background

Never leave your music at home
Never leave your music at home

They only play the tv on one station
In the lobby.

the sci-fi channel or something
Sometimes there are cookies full of M&M's

King, don't touch the cookies baby!
King, don't. touch.the.cookies.

I made up a job, because my job
Is not a job and apparently told them
i make too much
Money
that doesn't really exist

So now i'll be allocated $12 a month for food

Art is a thankless job
Weldon Irvine
(Who co-wrote "To Be Young, Gifted and Black")
Would whisper in my ear
At the Schomburg in Harlem
Before he killed himself a few years later.

Thankless Thankless Thankless
Thank you Thank You Thank you

Joni Mitchell & Nina Simone
 to drown out these moments
 Thank you Imani, Sate, Steffanie, Tammy, Angie,
 Charlotte

and even Beyoncé, for that song,

"If I Were a Boy."

Thank you Angels, past lovers
thank you patience
thank you bravery
thank you peace
thank you resistance

Thank you Mos Def for telling me it was honorable
To live my life, travel the world and when people ask me

What I "DO"

I simply say, I am a poet.

Thank you Talib Kweli & Sonia Sanchez
for friendship & activism
Ossie Davis for that elbow nudge into my arm
& your smile
Thank you Nana for
buying coats and uncles for shoes

Moore Family
I have more family.
I was born a Moore.

I'm headed to LA for some shows
I have to stop crying and write this poem

But this is not a show
This is my life

God.

this is my gift

Got a gig in London
While I was writing this.

Next month's rent

Thank you.

Daddy. God, Ancestors
Past lovers. Present Lover.

Got your text baby, I'm ok.

Poems.

This is what i have to give.

I'm eating poems today.

I'm thankful
I'm humiliated
I'm embarrassed
I'm surviving

I'm writing

Dick Gregory just died
Ruby Dee just died
Amiri Baraka just died
Jayne Cortez just died

You can't stop us
You can't stop us, no

Love
Is
Health
Care.

& Gratitude is a
 recipe for survival.

This is my job dammit
This is my job, you know?

We are mothers.
Give us our checks.

I am a mother
Give me my check

Amen.
Amen
Amen.

Always honey
Always sweet

A poet
A woman
In yellow
mixed with apple cider vinegar
A grandmother in Flint dicing garlic with prayer
A beautiful boy in Harlem sipping hot green tea
A princess born into poverty baking poems
Inside peach pies.

You can't find them
You can't find me

We are busy outliving our circumstances
We are in Ntozake's kitchen boiling a fearless soup
Of survival for colored girls
We are busy confusing your paperwork
with real life.

My lover says he speaks to me in real life
The internet is an illusion
Health care should not be an illusion

people are addicted to illusions though

Thankless Thankless world . . .
Not me not me not me not me not me not me not me
 not me
Not me Not me Not me Not me Not me Not me Not me
 Not me.
not me.

(Thank You)

They Say She's Different

*(Betty Davis and all her metaphorical daughters.
After 15 years of Black WOMEN Rock!)*

birth is a sound. she was born Mabry. Carolina farm girl.
steel lungs, quietly adjusting into Pittsburgh legs,
long as freight trains. eventually carrying us to
an unrecognizable place. unfiltered feminine funk don't
know boundaries.

can't just quiet down a train moving at full speed.
not wearing those feathers & history and wild rebellion
as leather necktie. loosen up miles. Betty
is in the building. inside your covers. on the notes,
brewing extraordinary fuses between
muddy waters bb king big mama thornton, lightnin'
 hopkins
conjuring jazz & electric high powered anthems
she wailed. moved. took them for an afro-futuristic ride.

Betty found herself inside a movement
that did not include self-defined, self-empowered
sexually confident women, especially beautiful
brown ones.

How high was that Egyptian leg kick, that pushed you into
american music non history?

How do you measure the time it takes to suspend your leg
minus the minds you blow when you finally decide to

Place it back on
 the ground

And howwwwwl
 inside the mic.

why do women, ordained as goddess, legend
get swallowed whole by the fears of the industry.

we just the blues sped up

?

who can hold a note while singing 'bout chitlins, beat
him with a turquoise chain, celebrate the sharing of lovers
from San Francisco to Detroit & shout out
john lee hooker as necessary blues in one heavy breath.

veins deep as spirituals. Betty told our collective story,
straight. without fear, no chaser.
this wide hipped music is spit out of a defiant flame
a hungry gut of midwest grit, of heart and
longing for truth.

authenticity was not sexy in the '70s
if you were a tall nubian killer of beauty,
Funktified fro as crown
growl of language, mask for no one. spun records & men
on her fingers.

sangin' anti-love songs.

black.
Betty.

jazz muse. Miles could not hold you the way
he played that horn. you loosened the tie.
made them beg. moved their minds
into uncomfortable places.

muses ain't for idle worship, you know?

you refused to tone it down for them.
you. daughter of Kilimanjaro
never turned your black scream into a purr
or bowed down to the phallic worship
of masculinity

hendrix and sly knew. you.

we just the blues sped up.

your music born free, inside a place some women
pretend not to recognize. you controlled stages
they wish they had the courage to touch.

hands & time

failing to grasp the weight
of your young genius.
your before your timelessness
that doesn't pay the bills, but leaves them guessing.

how did she do it? How did she survive?
outwit a young rock & roll death
choosing life
being fully awake can be lonely

how do we breathe, still?
your metaphorical daughters
they will forever wonder
this alien place that works to silence black women's
voices their entire lives, then labels us "crazy" when
we finally decide
to stop talking to them.
refuse interviews or access
to our souls.

How did you balance being from
the future in the past? to be the queen of funk. a black
rock in a land of pebbles. being black genius
& sexy was so confusing for the often low vibration
of this planet. the industry was not ready
& still has not recovered from the powerful likes of you.

Betty Davis

Where are all your Image awards
Your rebellion statues in your honor

?

They love looking at us, once we've turned to stone.
You forever our black rock.

Jazz's conduit into the hereafter
in this place that kills kings
& destroys the magic of women

you continue to live on.

*This poem was written the same day I received a beautiful card
in the mail from Betty Davis, with the handwritten note: "Dear
Jessica, Thank you for keeping my music alive. Best Wishes and
Love, Betty Davis."*

We, Too, Sing America

With the flag at half mast
What will we stand for in this hour?
What honor left in this land of the

Free

?

How do we matter, and who's
listening to our voices.

Maya Angelou's Caged Bird on repeat
 This morning.

Some of us didn't just wake up
Some of us knew that our ancestors built
the railroads. The blood-salt of
These crystal mines, and the concrete poured
Into these streets.

How will we explain to our children
This was America.
50 years after
riots burned down our cities

Who will speak for the unborn
The new women in black the #metoo
Whistles blowing the truth
Inside a bitter cold.
We
moving the globe, turning history on its axis.

Indigo as the Atlantic
Sun kissing the politics of the day
How will we survive this dialogue
Of walls, travel bans, religious and class divisions
& tales of two million cities and not enough
Food for our children

?

Whose hands will claim the victory
Who will touch the wet graffiti bricks
Skyscrapers replacing the pyramids
There is honor in hard work
There is no honor in blind patriotism

Jesse Owens was an eagle
And our eyes are still on a sparrow,
Waiting for our stories to land on
a ring of giant uprooted trees.

Some of Billie Holiday's strange fruit never ripened
into manhood. Emmett Till was a boy, a poplar tree flower,
and so were Tamir Rice and Mike Brown.

Josephine Baker was a Phoenix, an empress
forced to use back doors of bloated theater
houses of indifference

colors are necessary

The gold fist of Tommie Smith in the 1968 Olympics
blues is the color of a Nina Simone record
The resistance pitch of our collective pain
A John Coltrane blue train
A Lee Morgan holy ghost Trumpet
Miles Davis Electric Red

Black is the color of my true love's hair
The frontline women of names we will never know
The ones we must remember.
Rosa, Coretta. Fannie.
Sojourner. Betty. Harriet. Ida B. Wells.

The voices of the men who will never come home from war
The wars that plague our own neighborhoods
The sound of a water hose, a weapon against a body
Of people.

The sound of silence swept under an audience
buried under our children
Left out of history books.

Who else but you to find them
To resurrect their stories
The same revolutionary way
Alice Walker came for Zora

I am young
but my bones remember everything
We are the ancestors' blink
in the eye of future storms

This land is my land
This land is your land

We are the buffalo and the black elk
We are the baton holders
The bended knee risk takers
Racing across race

Climbing up flag poles
Tearing down Confederate statues

This is not fake news.

We walk with the tenacity of Thurgood Marshall
the poetic wonder of Ali
Reclaiming our time with Maxine.

Butterflies bursting
We, too, speak of freedom in the 21st century
caged birds, born again free
the four little girls who will never again sing
the metaphor for survival
An Aaron Douglas shadow headed east
An Elizabeth Catlett bust
sculpted from bronze beauty and genius

We are Kaepernick's bravery
& the power of Serena's
Right
Wrist
We are Eric Garner's last breath

We are all we have left

These hands
These voices
These colors
These stories

Those light ones, those dark ones,
Those dreamers, those indigenous,
Those yellow ones, those red ones
Those young ones, those old ones

Our bodies
Our hearts
Our minds

We, too, Sing, America
We, too, Sing. America

Are You

Listening?

The Beneficiaries

Why do you write about the future?

The future needed me.

Too.

Stars are the brightest light of this world
Night sky blurs into sun's reflection

We become Days, undefinable

Billie, Nina, Alice, Etta

A beautiful body of clocks
A fearless body of work

Some of us preserved our art
Like southern peaches in grandmothers' mason jars.
 When opened, history, pours out.

Some of us hid our passion inside our locs
Every 24 hours

No longer confined to hands
or race, or gender.

Sleep occurs when we find it necessary
Love is not a metaphor, but the way we always say

Hello & goodbye

We have finally become
a people.
An unstructured community
Of hope, of unfiltered discovery.

Our turquoise and red clay colored wings
Span galaxies, forgotten by many
Some of us remember the light years it took us
The bloodshed, the sacrifice, the undertow, the
Crossing over, the tides we conquered, the sandpapered
sweat of our royalty once unmasked

scraped to perfection.
Allowed to exist as
beams of light, fire of crowns.

We followed our steady pulse
Our movement from rock to purified stone

From agony to triumph
To arrive at this place of

solace & wonder

We are the beneficiaries

The gifted blues
Communicating through telepathy

We, found objects

Fragile Hematite hearts, carrying the keys to the universe
The trailblazers who dared to consider
Breathing & building beyond the clouds

A forest of Redwood Trees growing from
The imagination of the twilight children
A strip of Saturn's rings becomes a
giant slide
 spills out to a playground of

Vinyl Great Lakes

We are the future Afropologists who found
Sanctuary in the meditation of sound waves

Who rediscovered themselves without a
Naming ceremony

Some things don't need to be said
Even, here.

Where all of us vibrate high enough
To speak without words
Touch is the absence of distance

The addition of energy
Minus the lies

Some call it math, we call it truth
We decided drawing outside the lines
Might be the road map to the ever after
A tribe of multi-tongued mouths, curious noses and almond
 eyes

Thought & energy
Replace skin & bone

Melting into the DNA of destiny
A digital afterlife a series of crossroads
A one string blues a Coltrane whole note
A holy water fountain

Where everyone drinks from the same stream

Pyramids floating along the feet of the emptied rivers
Mississippi, Nile, Jordan, Euphrates
Stories suspended in time
Wind choosing to change directions

Sea. to. shining.

Moon-lipped women carrying centuries of secrets
In one kiss. Warriors who fought to be remembered.
Passing down the magic of growing younger
& gardening the fields of forever

Hieroglyphics is the new cursive now taught inside
Classrooms without walls
Interstellar peace is a reachable destination
We are the mirrors of memory
A kaleidoscope of electric jazz & ancestor notes
Broken up into waves of head nods & hollow speakers
Says our teachers of tomorrow

Children are the new Gods.

Our collective imagination bound inside
levitated books. All medicine is pulled from

the gritty soil of our backyards
as well as the engines of
 Our flying, cosmic cars.

Rhythm rains dreams from our pores.
In the specs of our speaker box limbs

We become
freedom of speech

We become the music
we eat, love.

Movement becomes the language of the fantastic
Everyone in unison, proper agile aliens of funk
A spiral reality leading us back to the source

Evolution of humanity
Forward is the ability to push
Boundaries invisible

Emancipation of labels &
Letting go our only way
of figuring out which planet becomes our
Home. civilian travel cannot accommodate
Genius traveling at light speed.

It will not be easy carrying all that sound
In your womb. Birth is noisy.

Still, we are still.

The Crystal City is Alive
The Crystal City, a blue burst of light

if you can truly see
If you unplug just enough
to actually feel

Your fingers—the iconography of keys

Our future will never become
a thing

of the past

ACKNOWLEDGMENTS

Thank you to my Creator and all my ancestors who have stayed close to me on this incredible journey of poet and activist. To the elders, scholars, activists, and educational institutions who have called my name when others have not—I love you.

To my mom Irene for eating all those books and birthing a poet. To my entire family and lifelong friends for always showing up for me. My fellow poets and artist community around the world for your magic and necessary work. Thank you especially to my beautiful birth son King Thomas. You are the joy of my life.

To my literary agent, Regina Brooks, for believing my voice deserved a bigger platform. To my editor Patrik Bass and the entire team of HarperCollins for your faith in this poet. Thank you poet Brad Walrond for the hours we spent laughing and editing this manuscript into shape. You are a gift.

To Sandra Bland, for your fierceness, bravery, and sacrifice.

ABOUT THE AUTHOR

jessica Care moore is an internationally renowned poet and proud Detroit native. She is a 2018 Joyce Award winner, 2016 Kresge Live Arts Fellow, recipient of the 2013 Alain Locke Award, 2015 NAACP Great Expectations Awardee, Harvard Black Men's Forum Woman of the Year Award winner, and the Poet Laureate of Courageous Conversations.

She is the executive producer and founder of the 15-year-old rock and roll concert and empowerment weekend Black WOMEN Rock! and the founder of the literacy-driven Jess Care Moore Foundation. As a strong believer in institution-building, she created Moore Black Press Publishing in 1997 and began publishing her peers—Saul Williams, asha bandele, Danny Simmons, and Newark, New Jersey, Mayor Ras Baraka. She is an educator and strong advocate for youth and women's voices.

moore is the author of *The Words Don't Fit in My Mouth*, *The Alphabet Verses The Ghetto*, *God is Not an American*, *Sunlight Through Bullet Holes*, and *We Want Our Bodies Back*. Her full-scale theatrical work, *Salt City*, a techno choreo-poem, premiered in Detroit in 2019 and is directed by Aku Kadogo, chair of the Department of Theatre and Performance at Spelman College.

moore has read her work and lent her powerful voice to many causes all over the world, including UN World AIDS Day NYC, Shanghai's Iron Mic Competition, and the Concrete & Grass Music Festival, and she has joined poets from around the world at the International FLUPP Literary Festival in Rio de Janeiro. Her poetry performances have graced the stages all over South Africa, the Apollo Theater, Carnegie Hall, New York's Lincoln Center, The Republic in Ghana, and the London Institute of Contemporary Arts. moore and her young poet son King toured Ghana, conducting workshops and reading poems throughout the country. Her critically acclaimed jazz soul album, *Black Tea: The Legend of Jessi James,* was released by emcee Talib Kweli's Javotti Media label. The poet captivated a national television audience in the '90s when she won the legendary "It's Showtime at the Apollo" competition a record-breaking five times in a row—with a poem.

moore's poetry and voice are prominently featured on the fourth floor of the Smithsonian's new National Museum of African American History and Culture. She is the proud mommy of 12-year-old poet and musician King Thomas Moore and a 24-year-old earth son Omari Jazz.

www.jessicacaremoore.com